SO-AVQ-936

Renditions of Tahoe

Juan Acosta,
Beata & Eric Jarvis

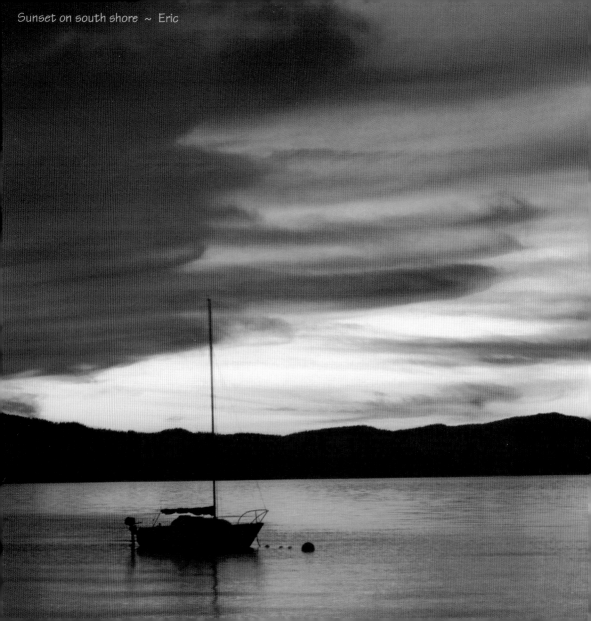
Sunset on south shore ~ Eric

Foreword

Lake Tahoe is truly one of nature's gems. Because of its many facets and its natural splendor, it captivates the photographer's eye.

This book is an effort to present some aspects of the Lake that we find most compelling. Due to its beauty and grandeur, we constantly discover new sights and details in Tahoe's ever-changing landscape.

The "Renditions of Tahoe" project was a year in the making. During this time we went out for many cold sunrises and strenuous hikes which were rewarding beyond description. We feel fortunate to be able to enjoy the serenity of the area in which we live and work.

We hope you like what you find here.

For additional breathtaking images of Lake Tahoe and several other exotic locations, please visit our online galleries.

www.jarvisgallery.com
&
www.vistapanorama.com

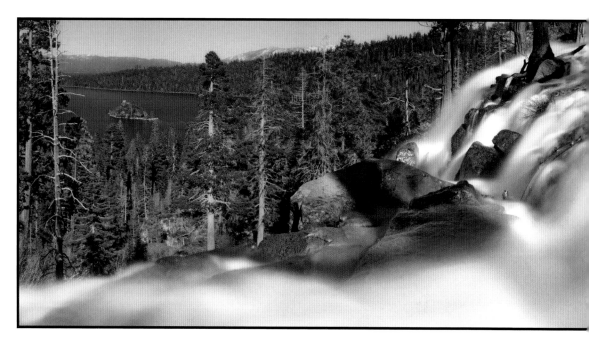

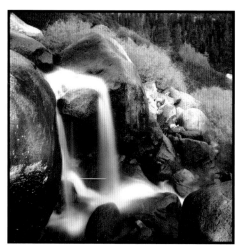

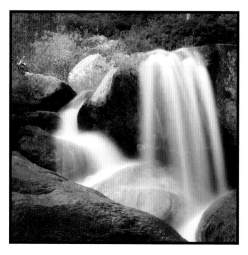

Echo Falls
~ Eric

Eagle Falls ~ Eric

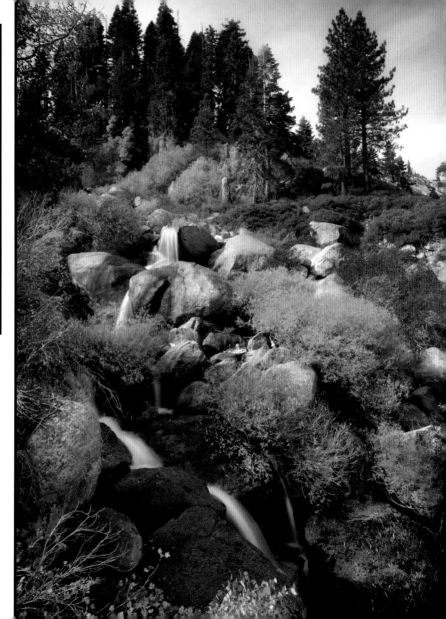

Echo Falls ~ Juan

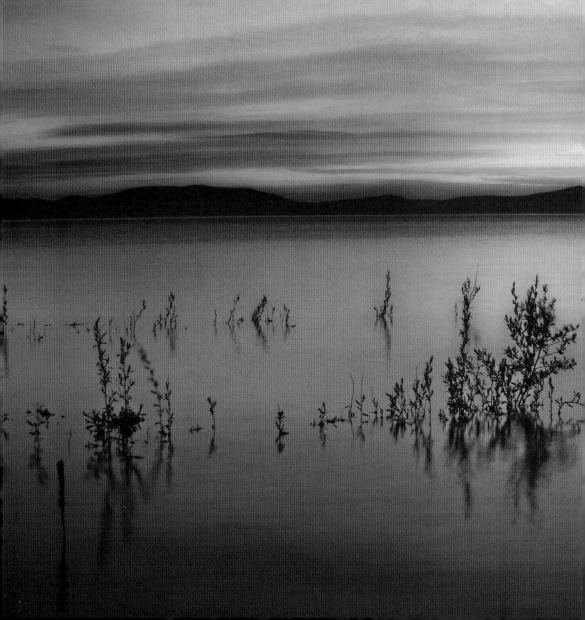

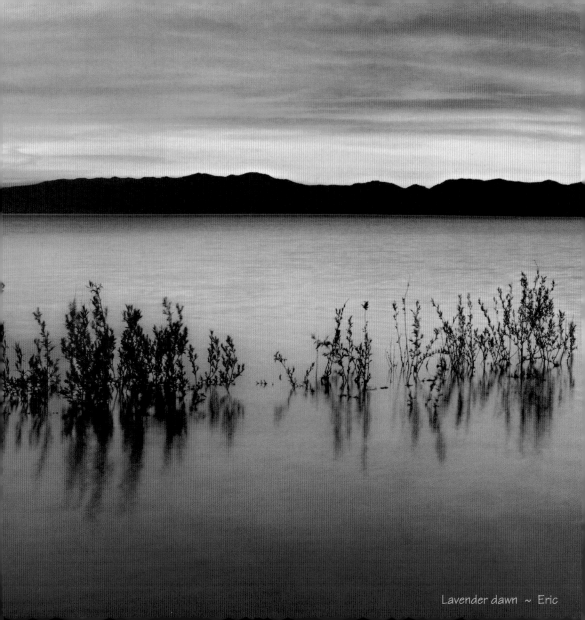

Lavender dawn ~ Eric

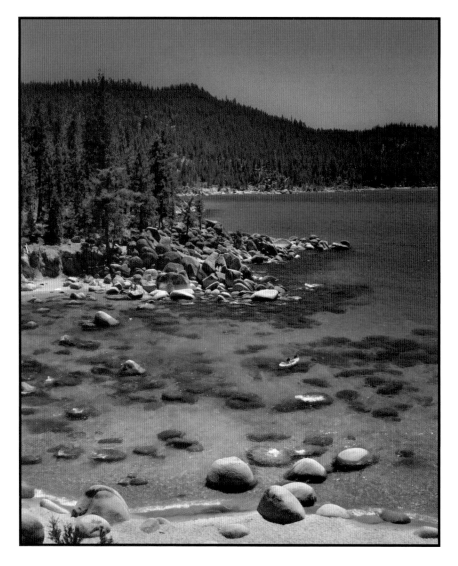

Kayaker at Secret Cove ~ Juan

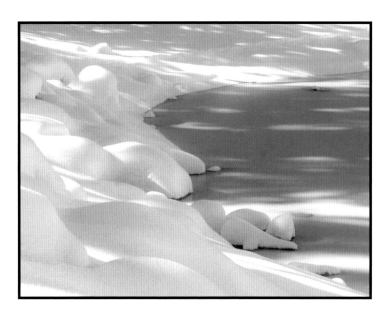

Frozen shore ~ Juan

Snowy curves ~ Juan

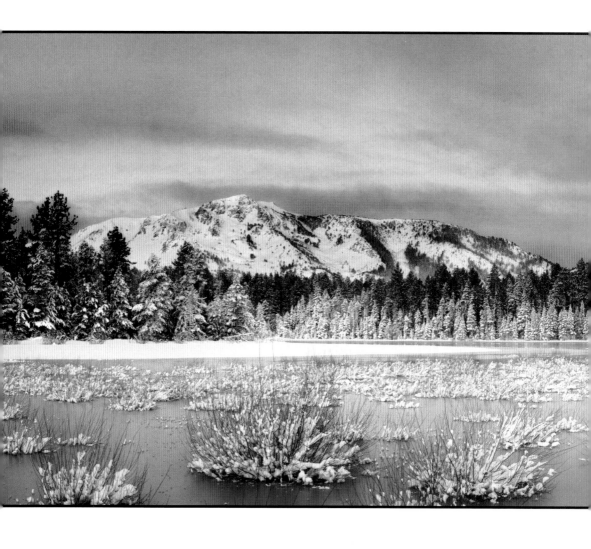

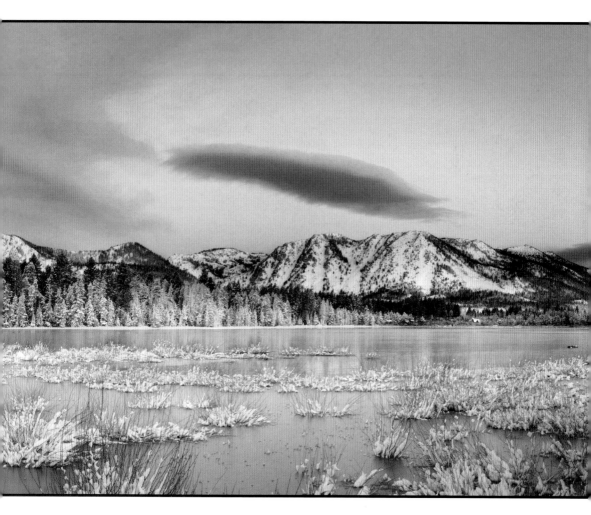

Winter sunrise over Mt. Tallac ~ Eric

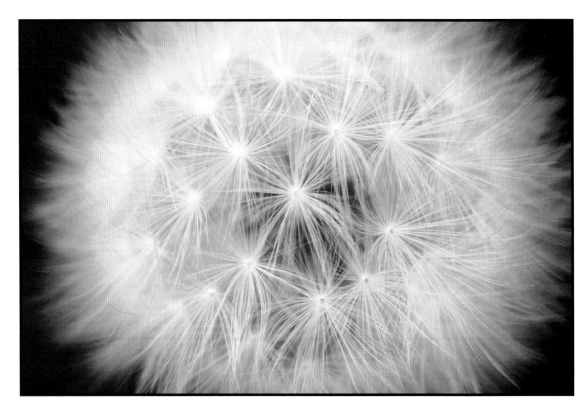

A close look at a dandelion ~ Beata

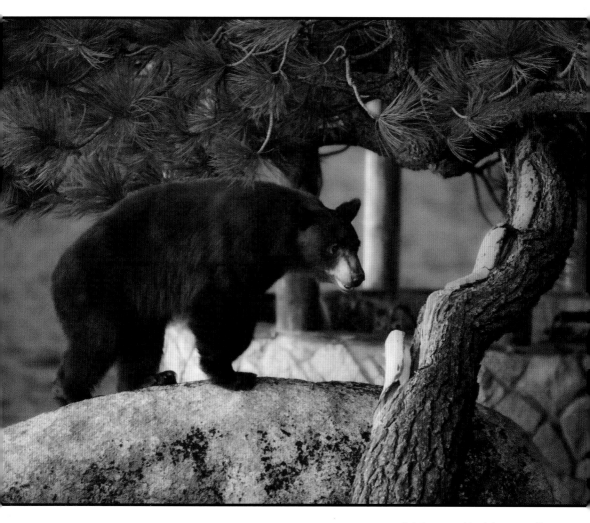

Adolescent black bear ~ Eric

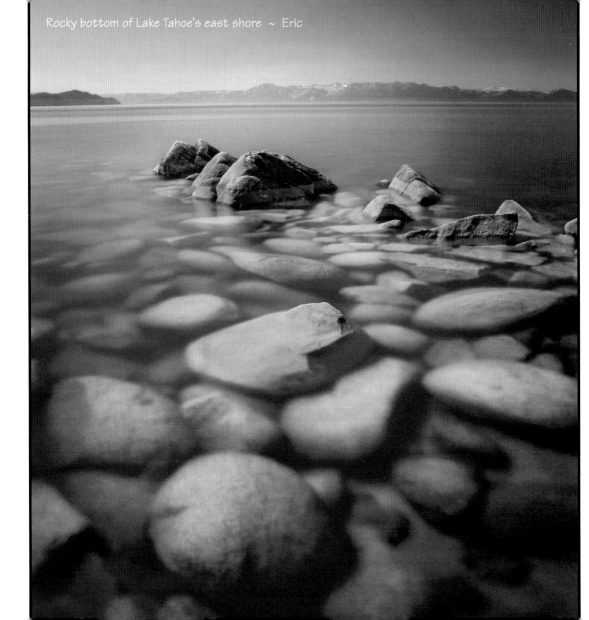

Rocky bottom of Lake Tahoe's east shore ~ Eric

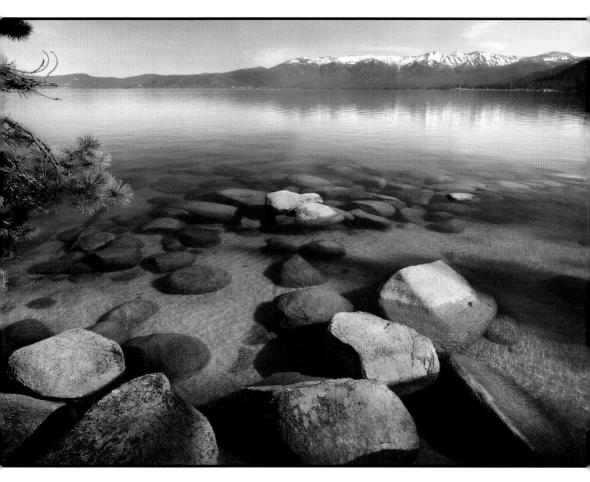

Tranquil waters of Tahoe at the Thunderbird Lodge ~ Juan

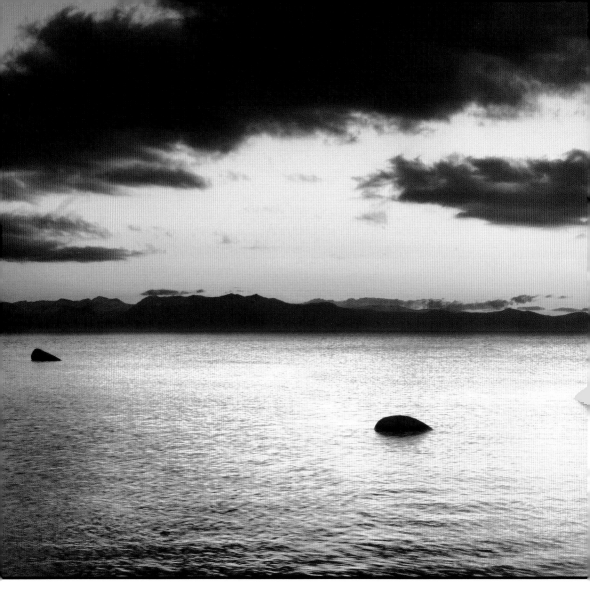

Sunset at Bonsai Rock ~ Juan

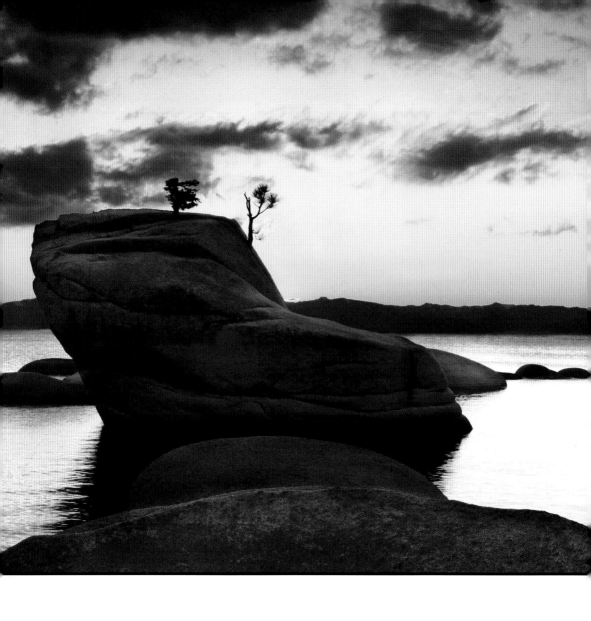

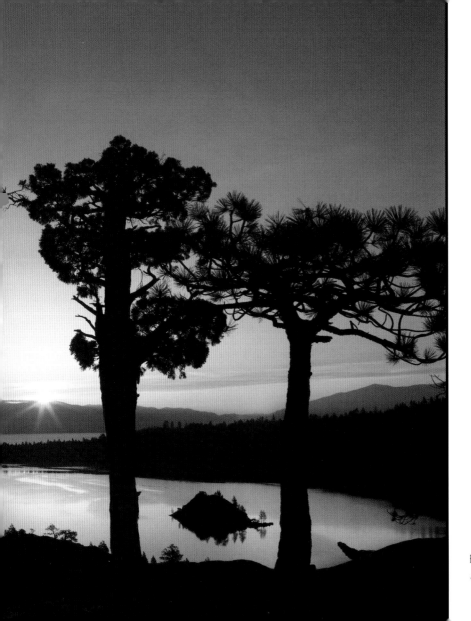

Fannette Island
at Emerald Bay
~ Eric

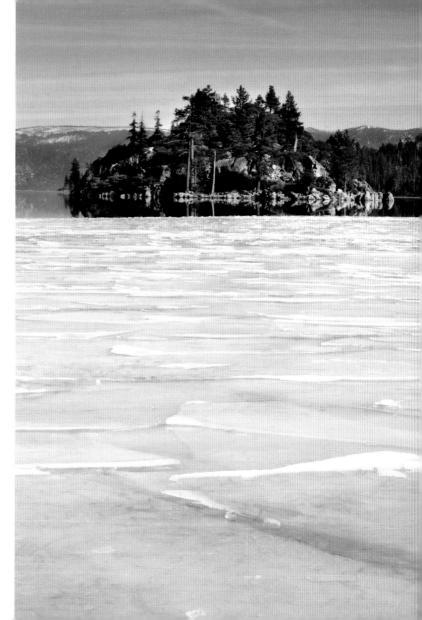

Fractured ice at
Emerald Bay
~ Juan

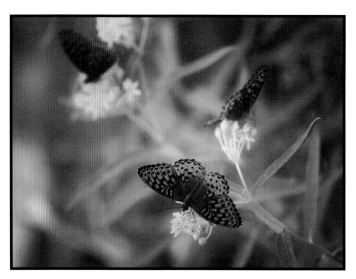

Butterflies ~ Eric

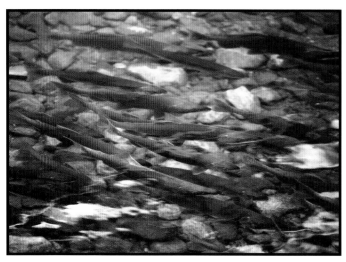

Salmon run at Taylor Creek ~ Beata

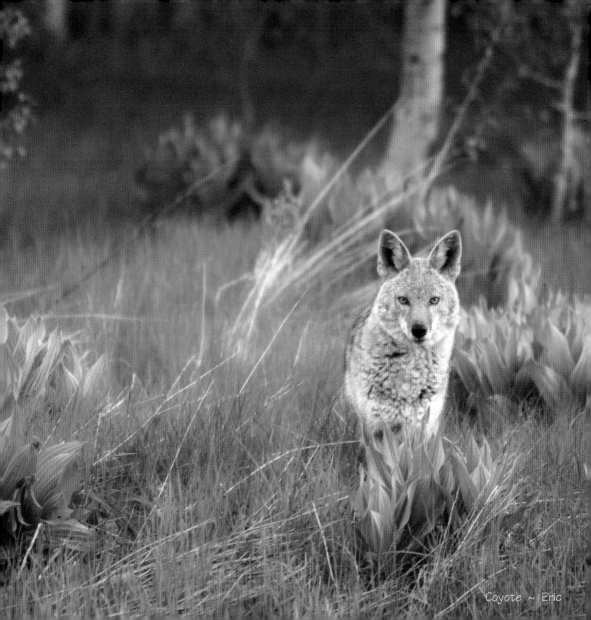

Coyote ~ |Eric

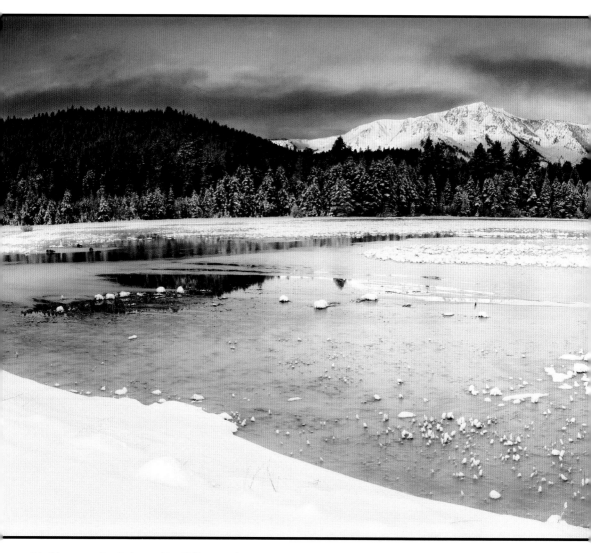

Striking morning light on Mt. Tallac ~ Juan

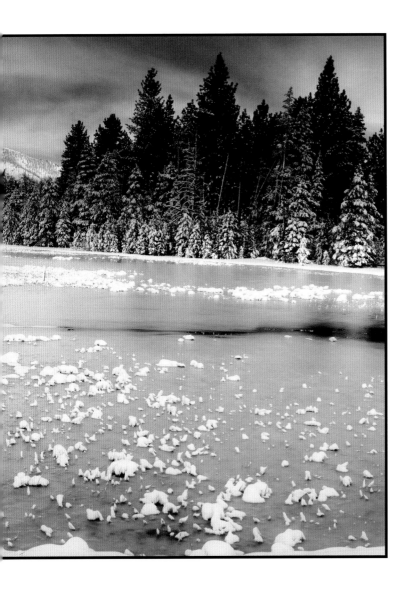

Sunny side up ~ Juan

Autumn leaves ~ Juan

Snow plant ~ Juan

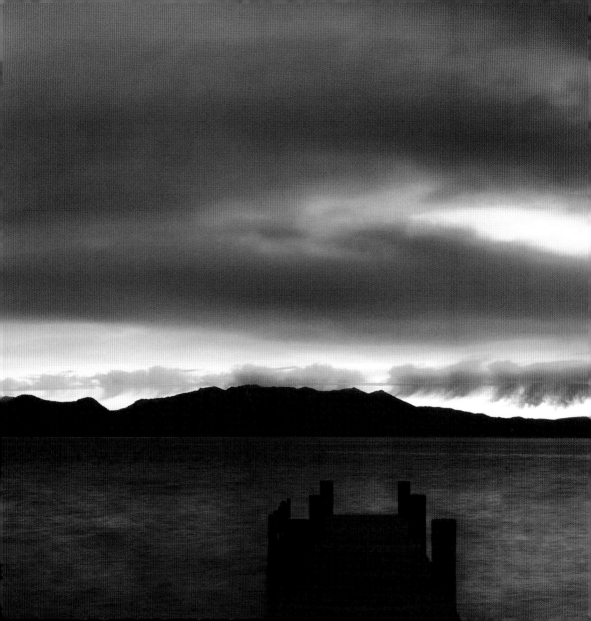

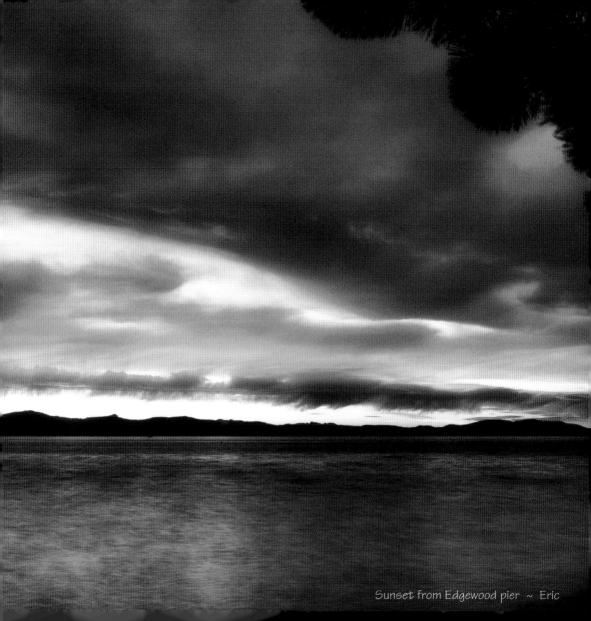

Sunset from Edgewood pier ~ Eric

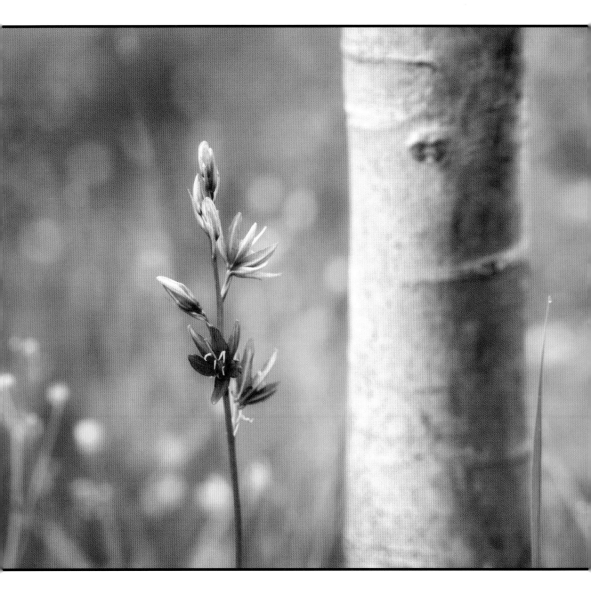

Spring blossoms at Cathedral Meadow ~ Eric

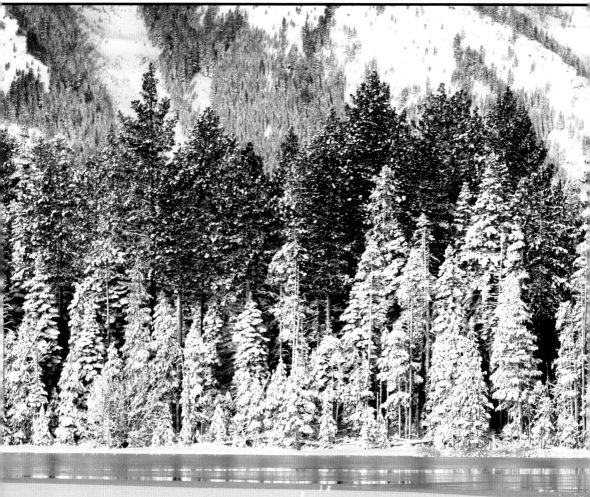

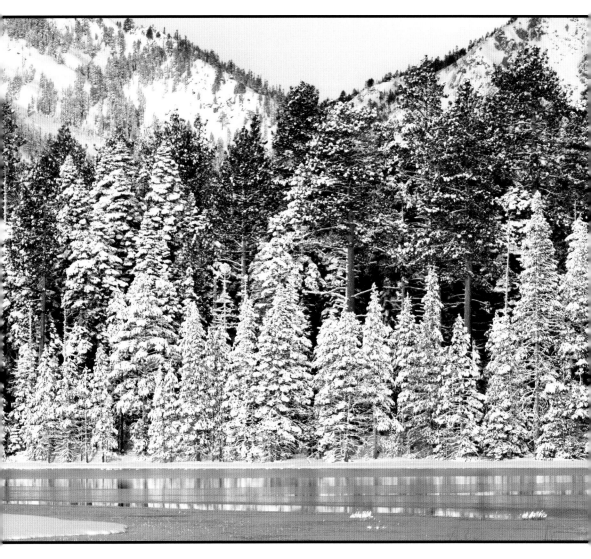

Frozen trees at the Tahoe Keys ~ Juan

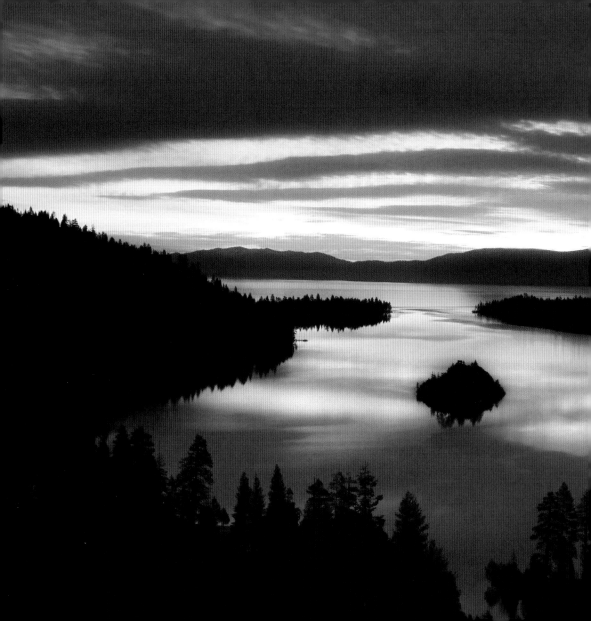

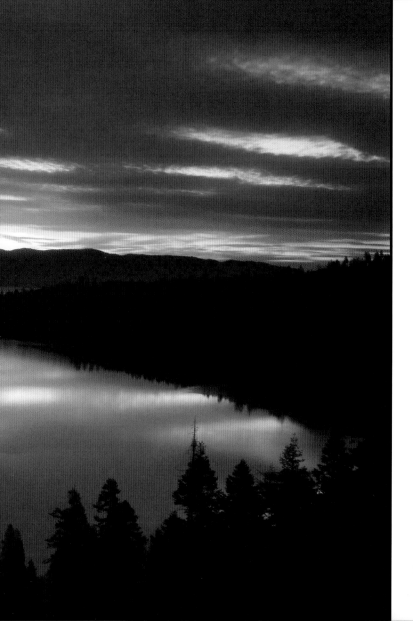

Serene sunrise, Emerald Bay
~ Juan

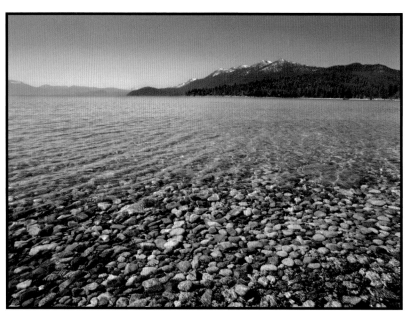

Tahoe pebbles ~ Eric

Rocks in calm water, east shore ~ Eric

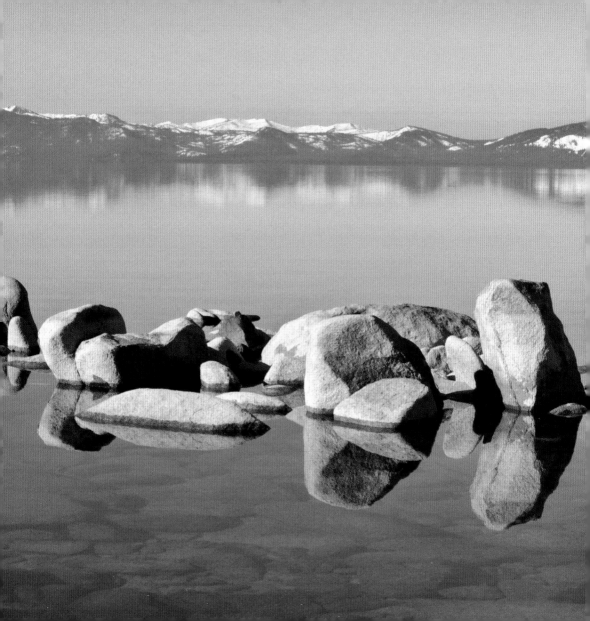

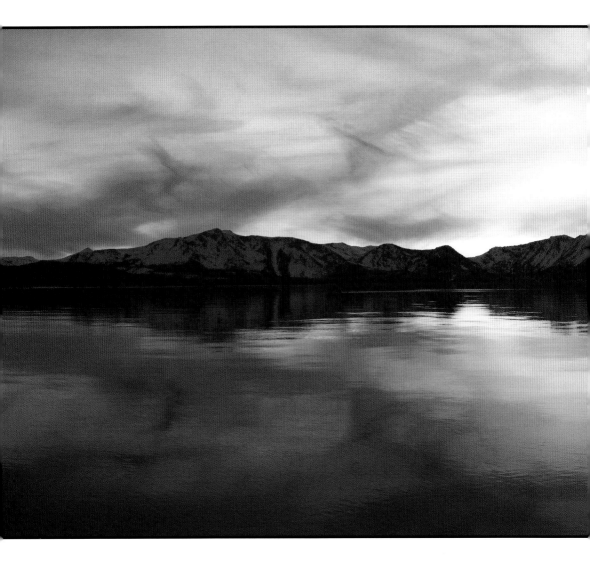

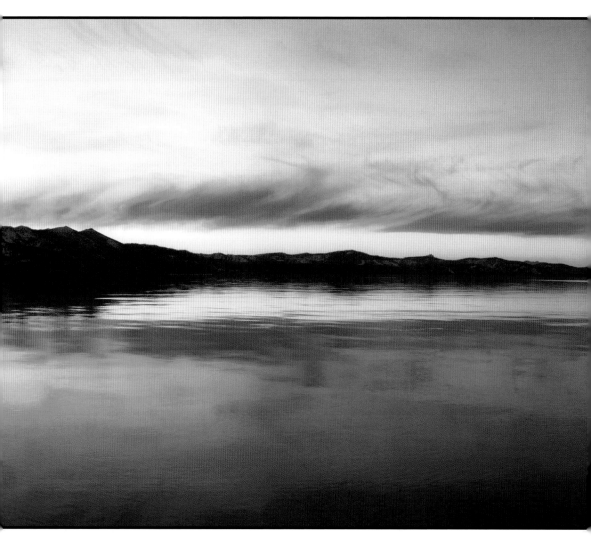

Wispy clouds over Mt. Tallac ~ Eric

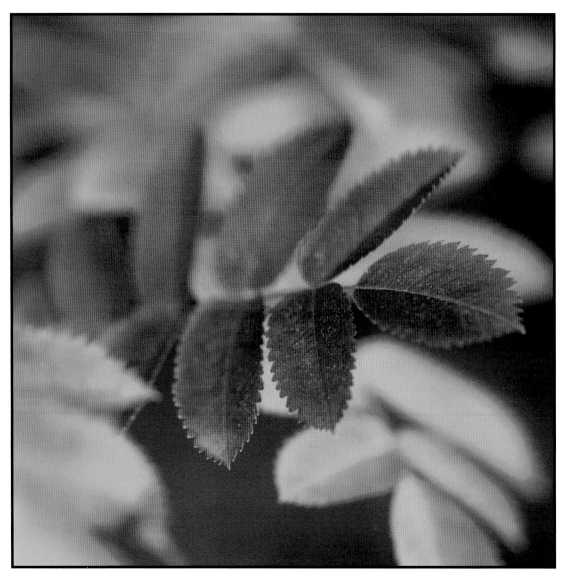

Autumn blaze ~ Eric

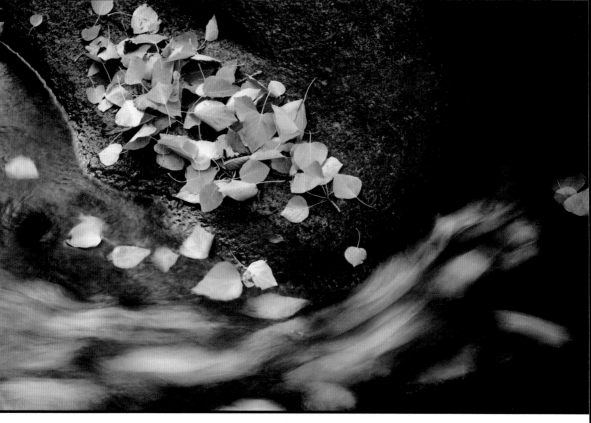

Autumn leaves flowing in Carson River ~ Eric

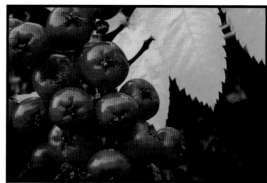

Red berries ~ Juan

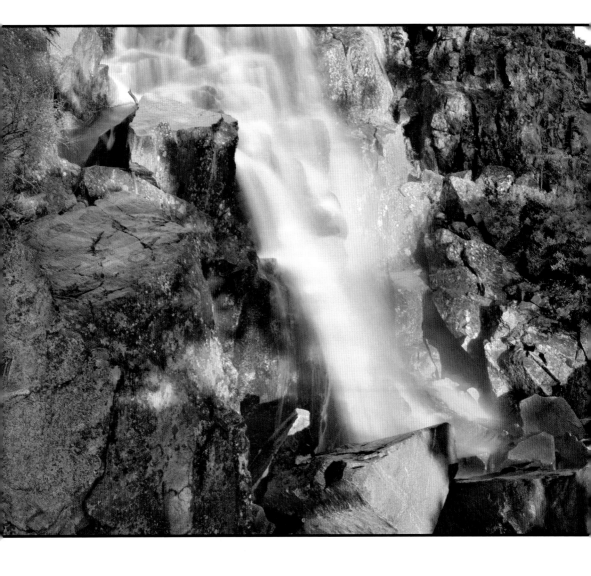

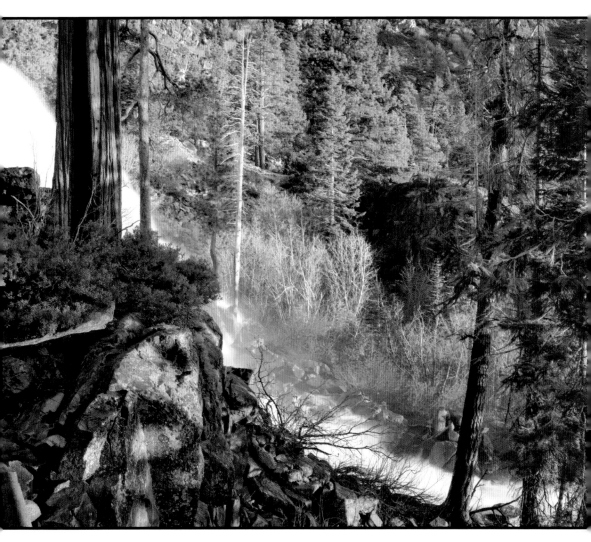

Eagle Falls in the early morning sun ~ Juan

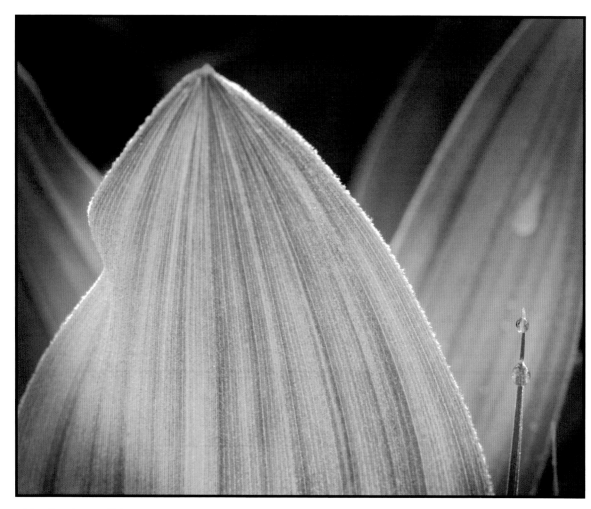

Morning dew ~ Eric

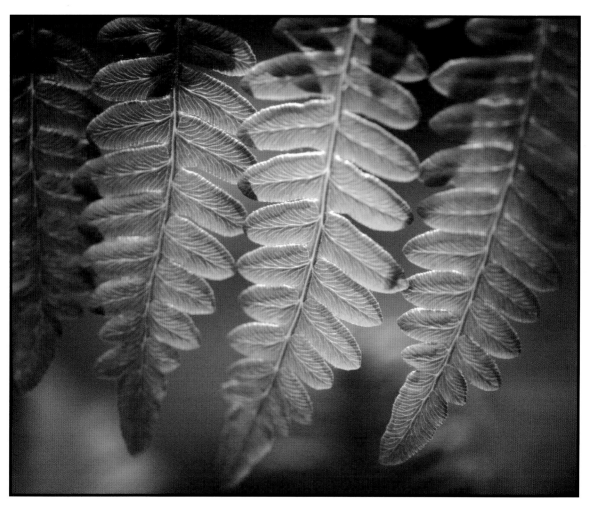

Delicate fern ~ Eric

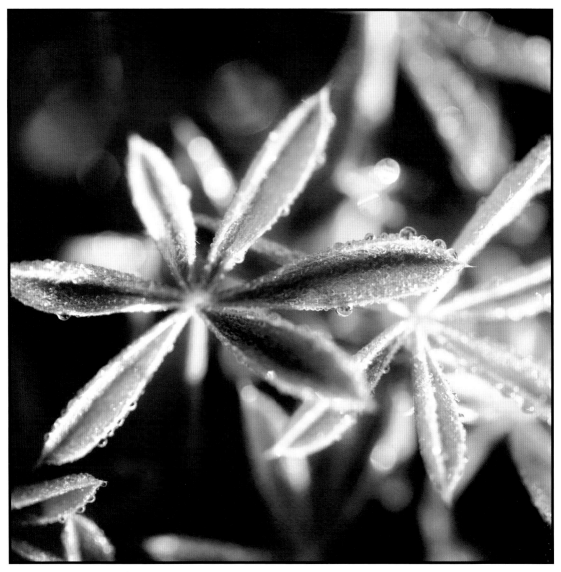

Sunrise mist ~ Juan

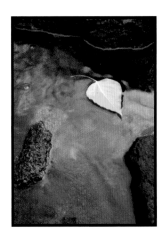

Floating leaf ~ Juan

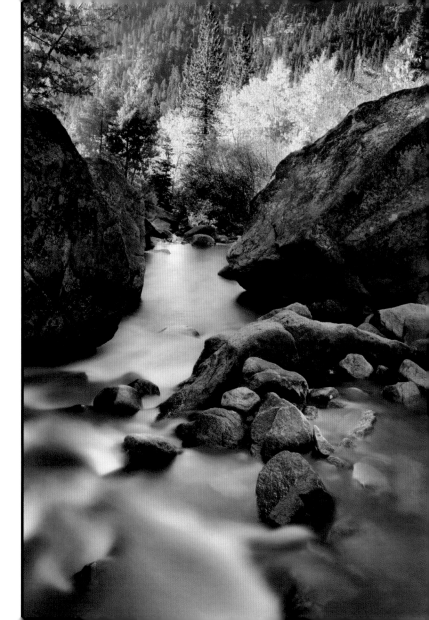

Fall colors in Hope Valley
~ Juan

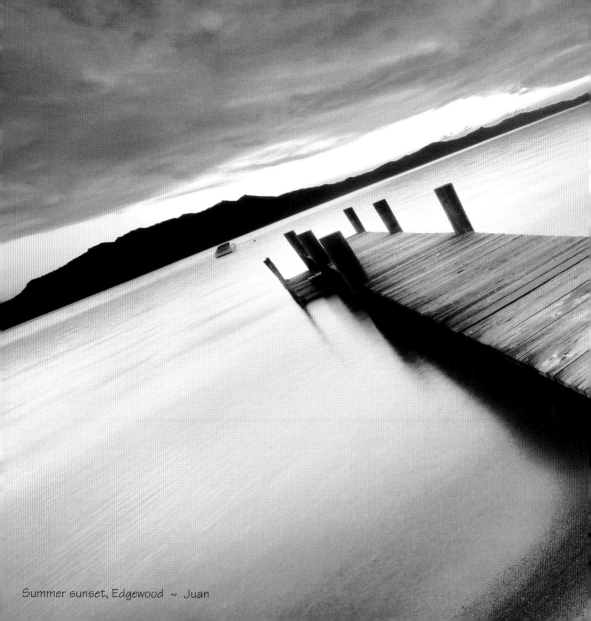

Summer sunset, Edgewood ~ Juan

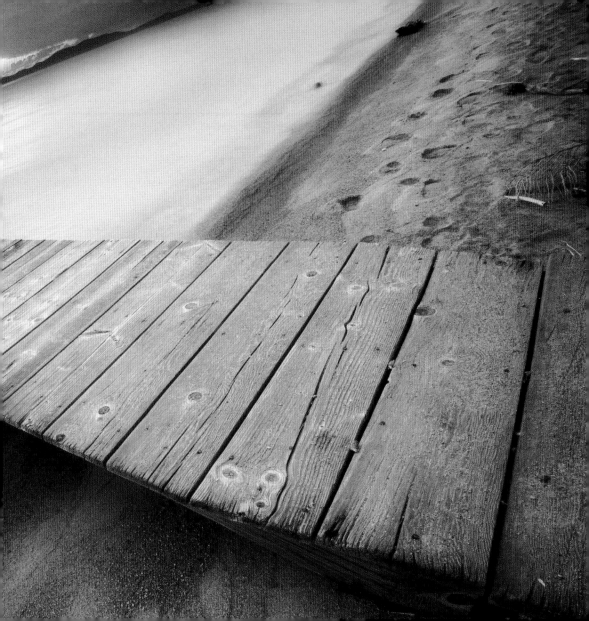

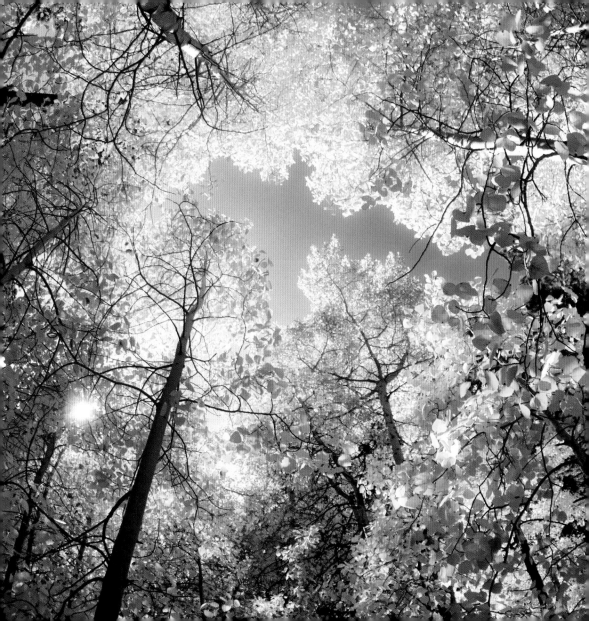

Blue sky over aspen trees
~ Beata

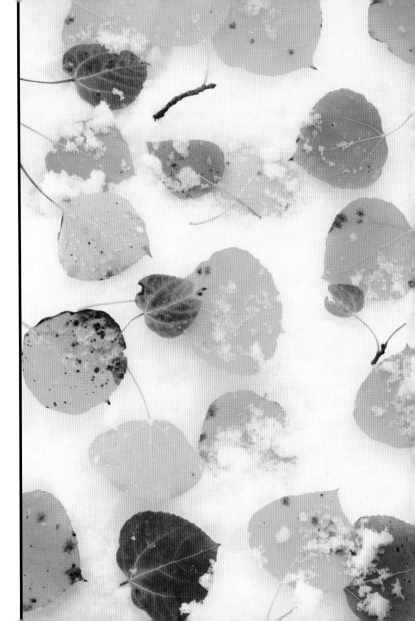

Changing fall colors ~ Eric

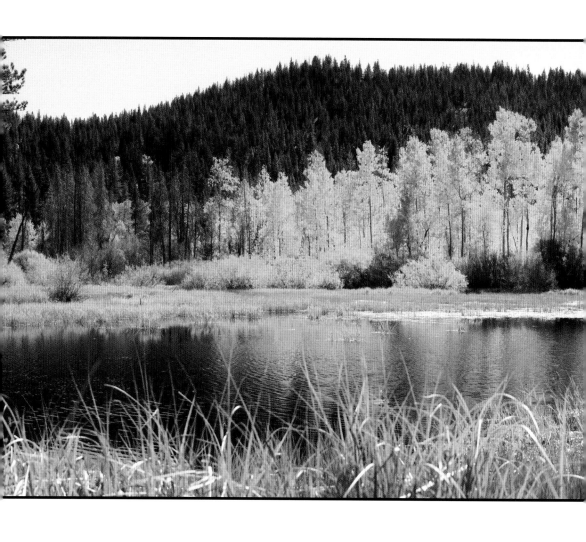

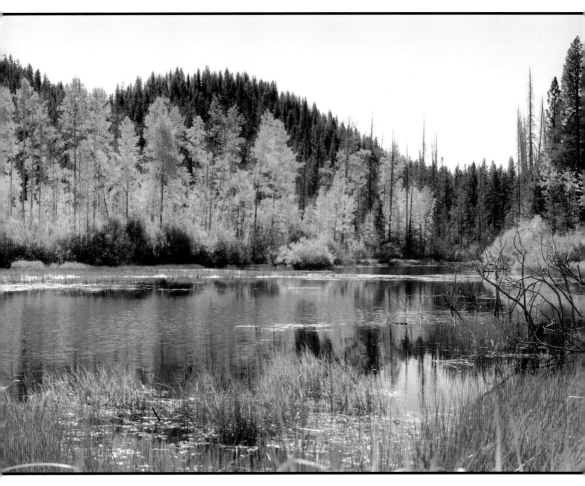

Autumn foliage at Spooner Summit ~ Eric

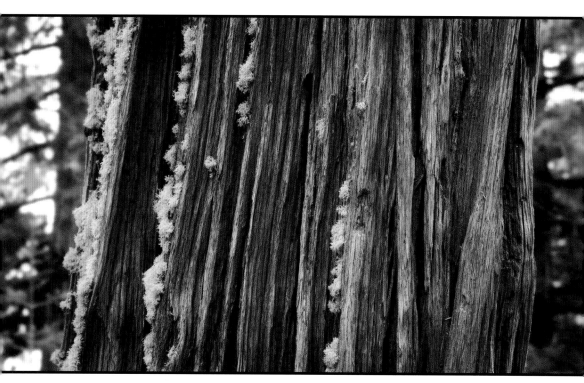

Moss on sequoia ~ Juan

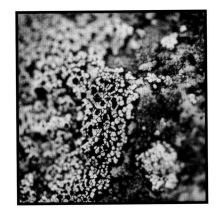

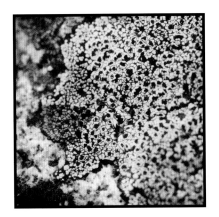

Lichen on the rocks
~ Juan

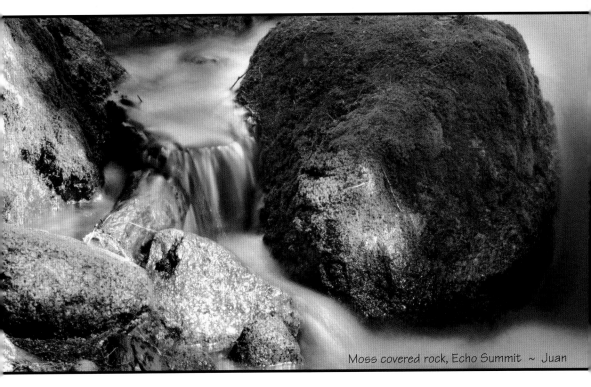

Moss covered rock, Echo Summit ~ Juan

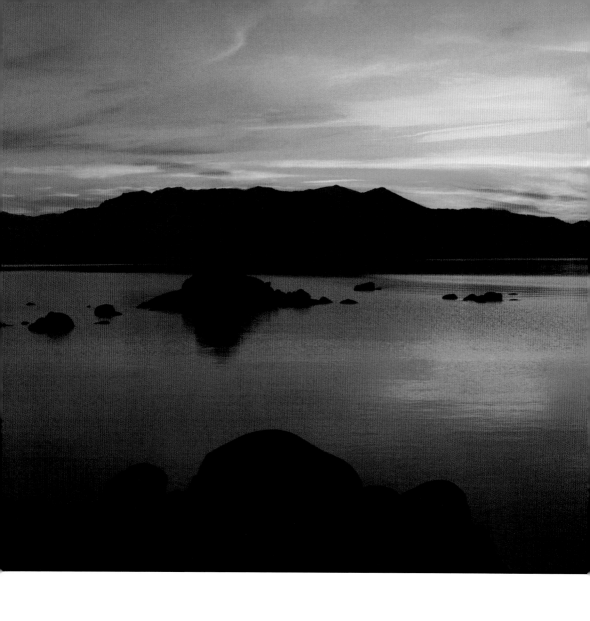

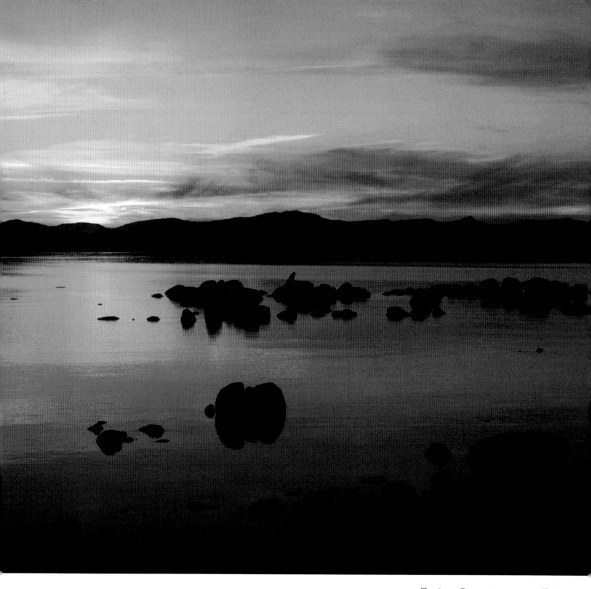

Zephyr Cove sunset ~ Eric

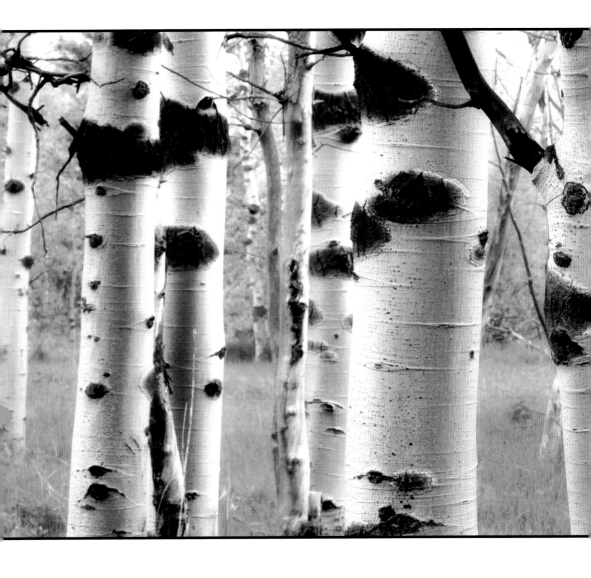

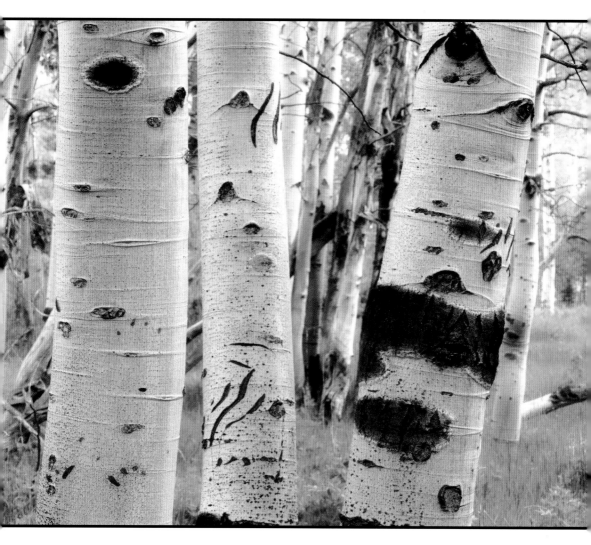

Bear-clawed aspens ~ Eric

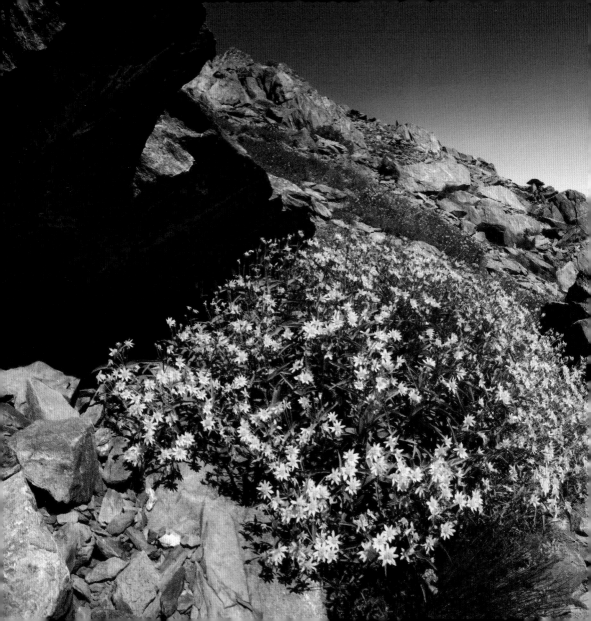

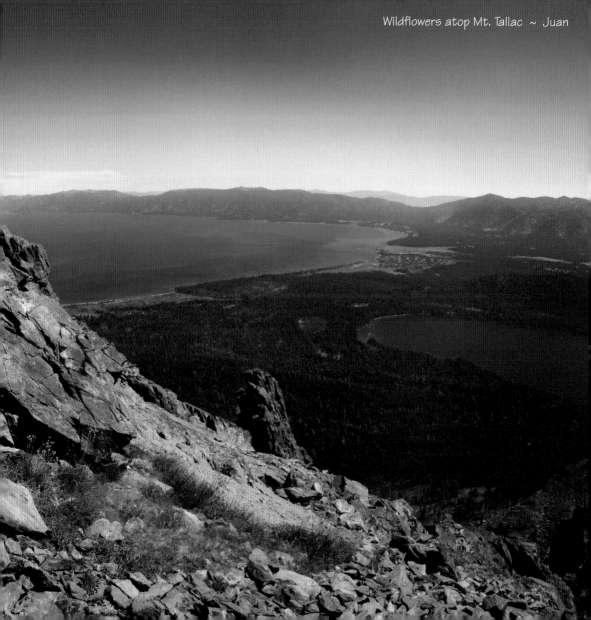
Wildflowers atop Mt. Tallac ~ Juan

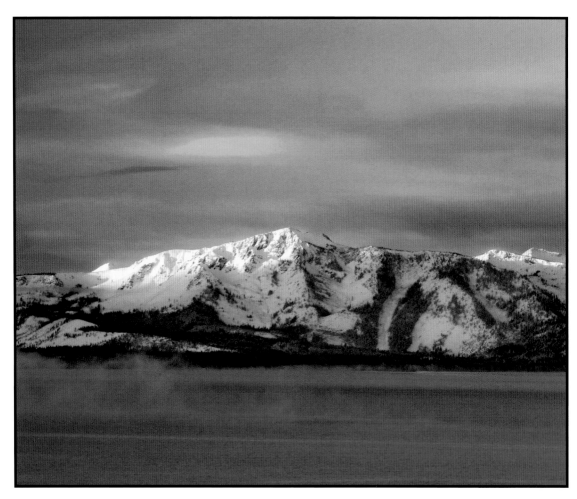

Mt. Tallac from Zephyr Heights ~ Juan

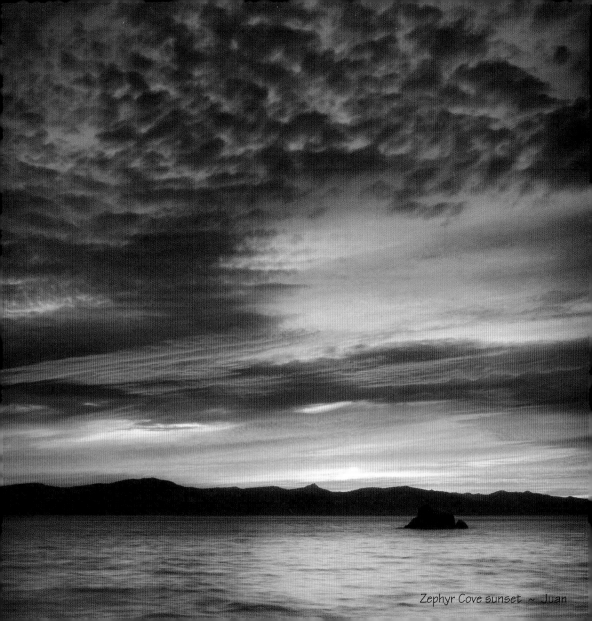

Zephyr Cove sunset ~ Juan

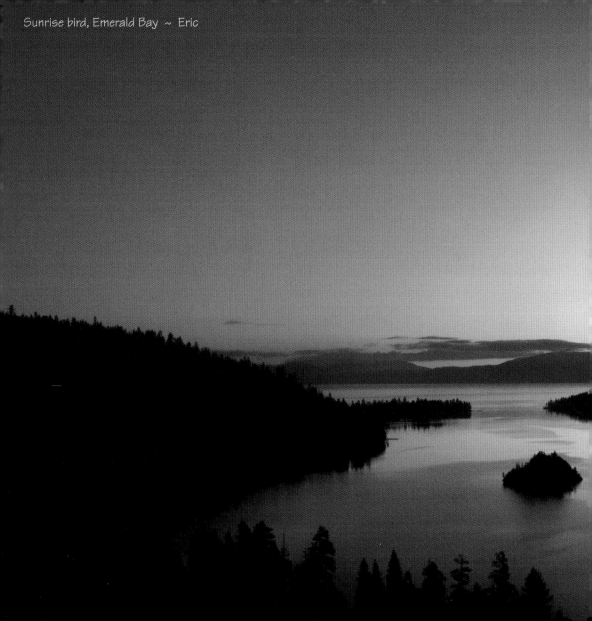

Sunrise bird, Emerald Bay ~ Eric

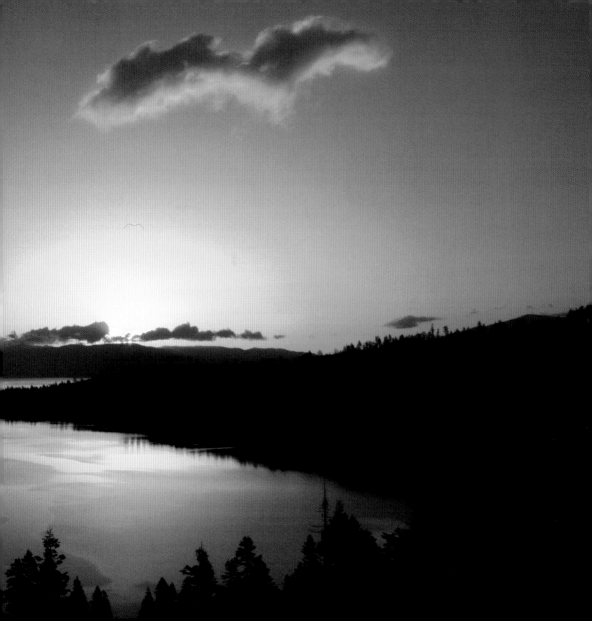

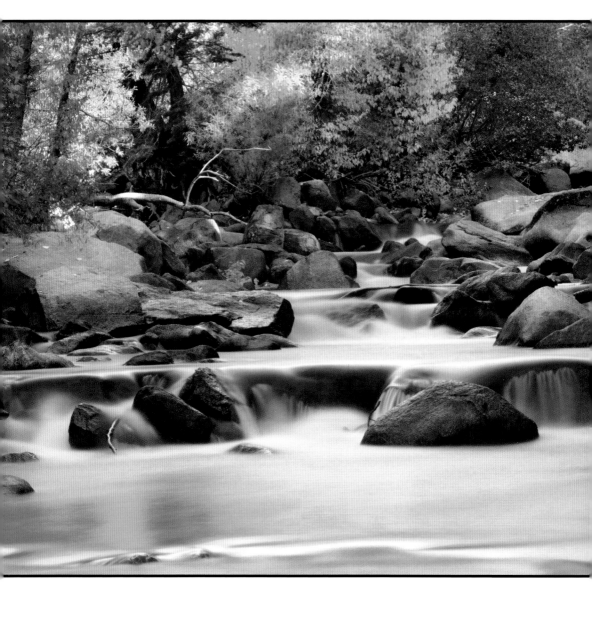

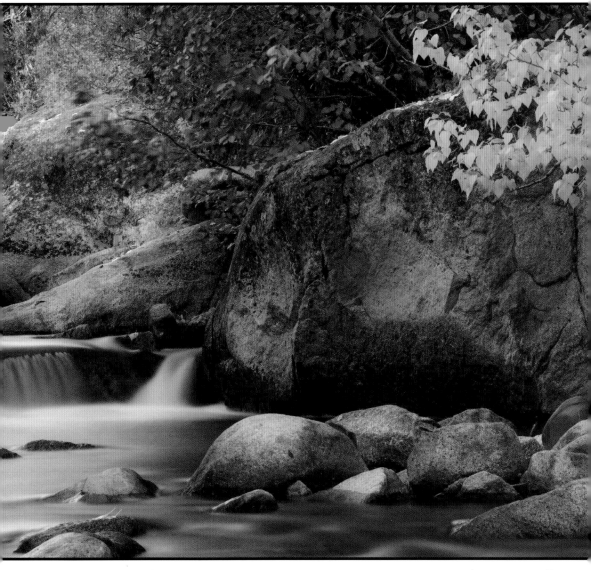

Luminance ~ Eric

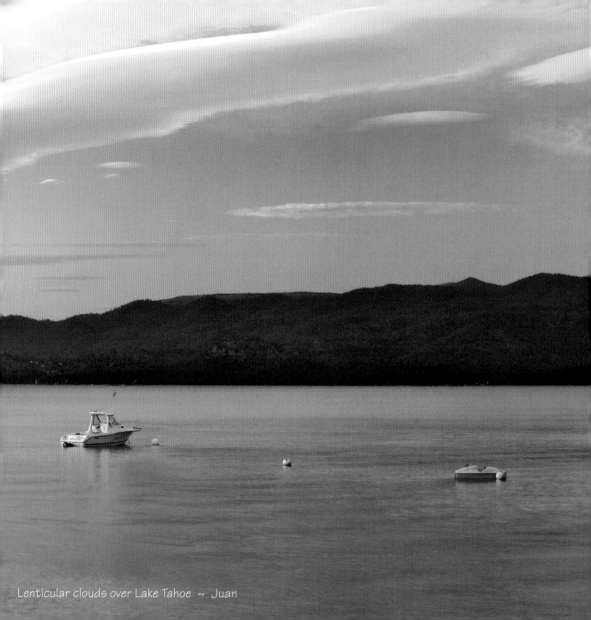

Lenticular clouds over Lake Tahoe ~ Juan

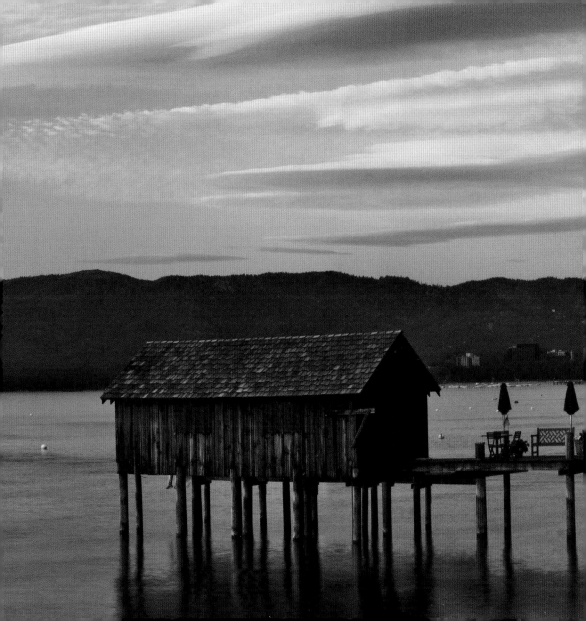

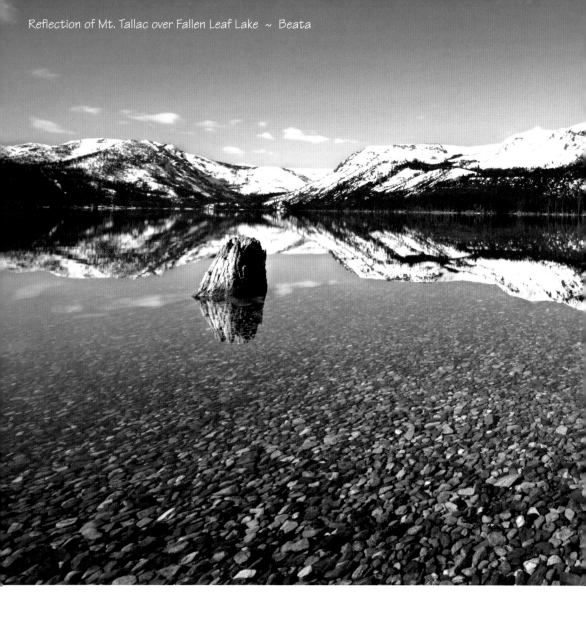

Reflection of Mt. Tallac over Fallen Leaf Lake ~ Beata

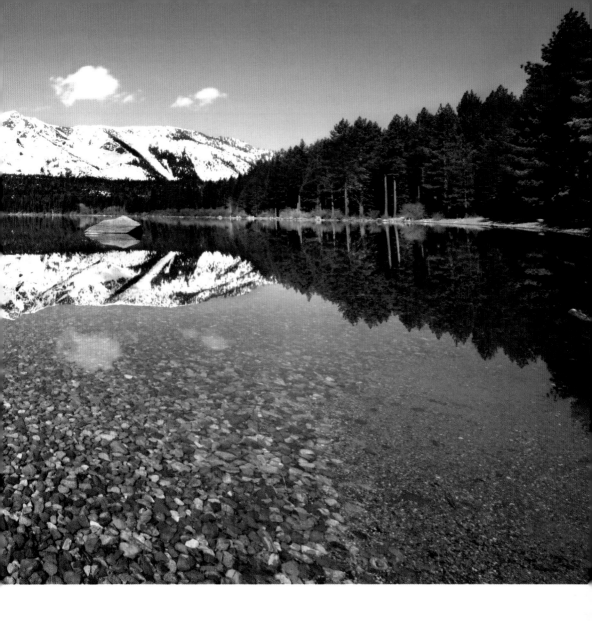

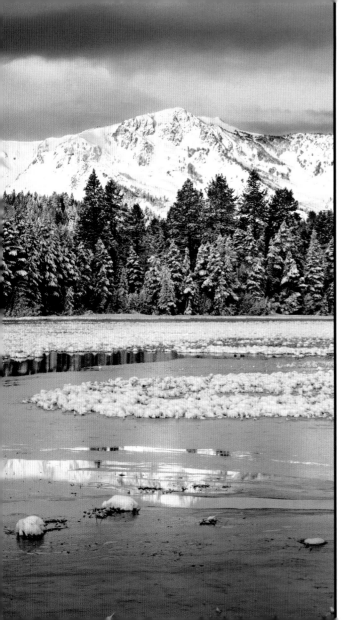

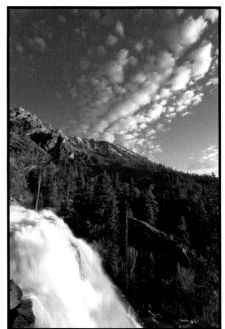

Eagle Falls ~ Eric

Mt. Tallac in the morning sun ~ Eric

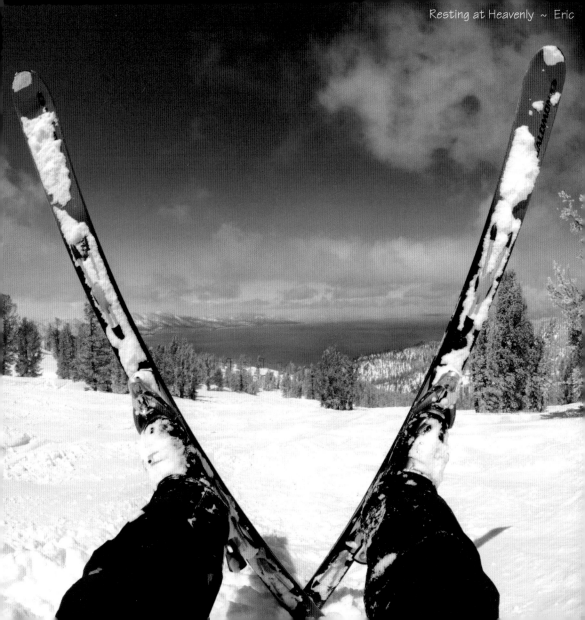

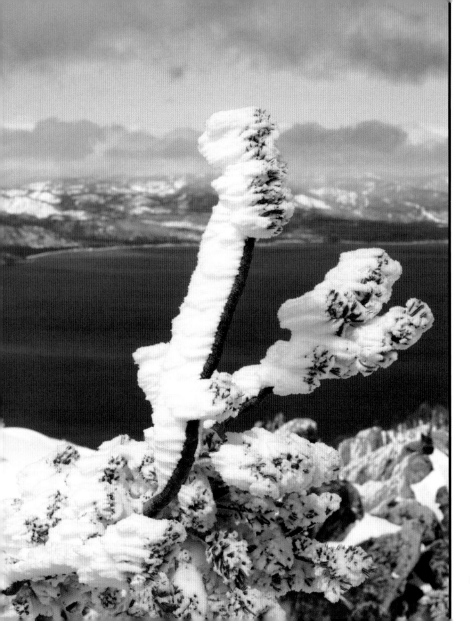

Snowy branch
~ Eric

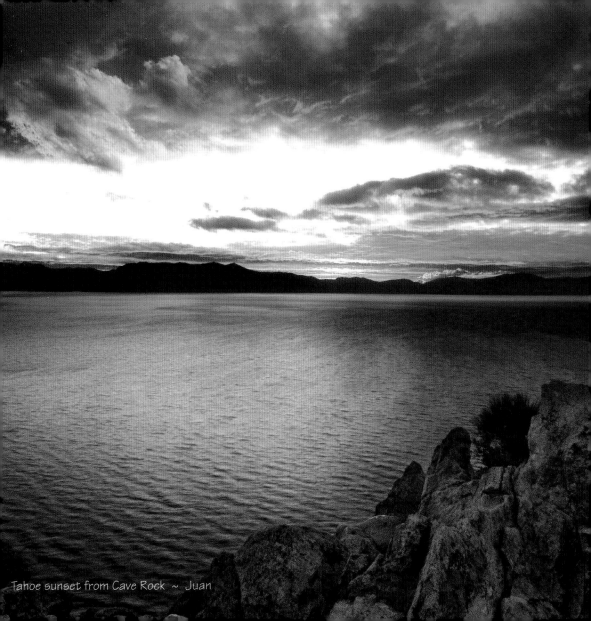
Tahoe sunset from Cave Rock ~ Juan

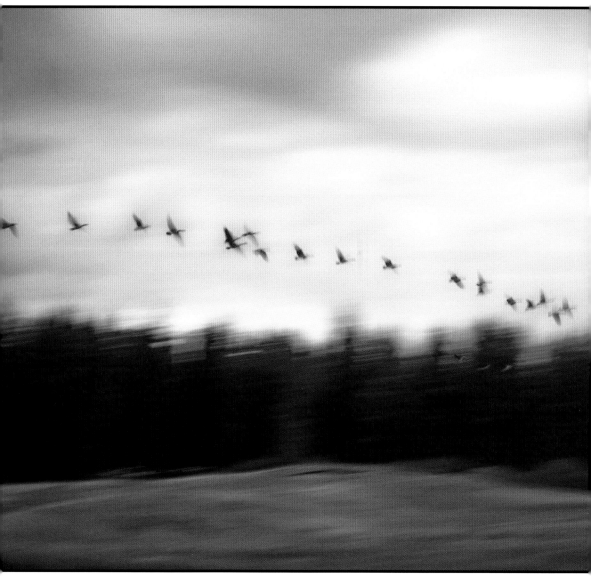

Geese flying over Edgewood ~ Eric

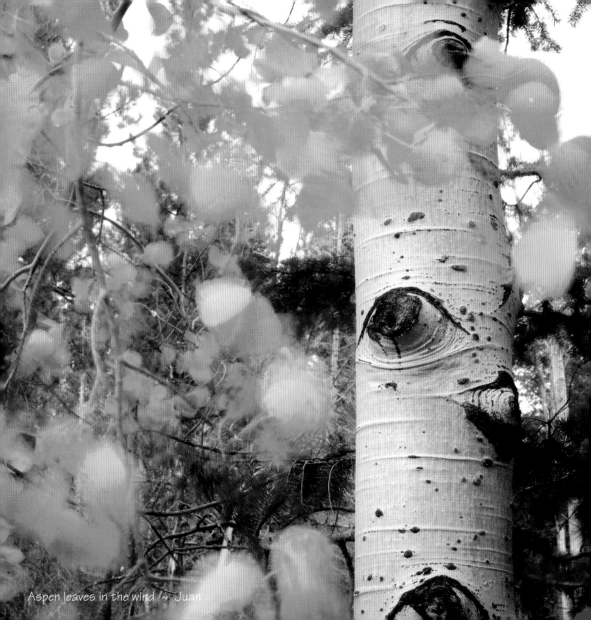

Aspen leaves in the wind ~ Juan

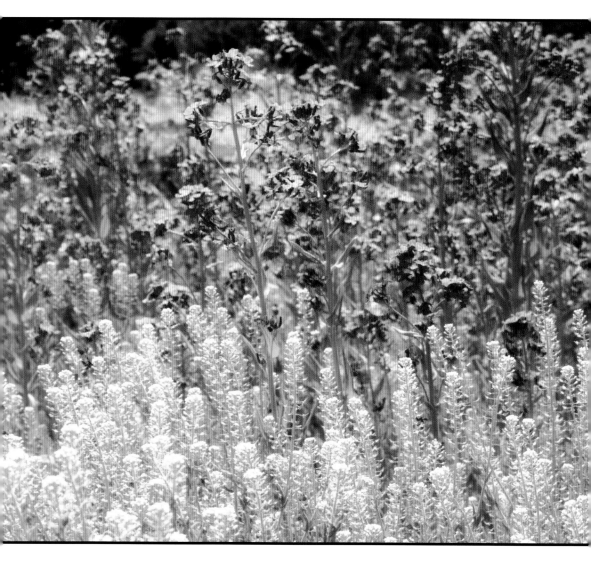

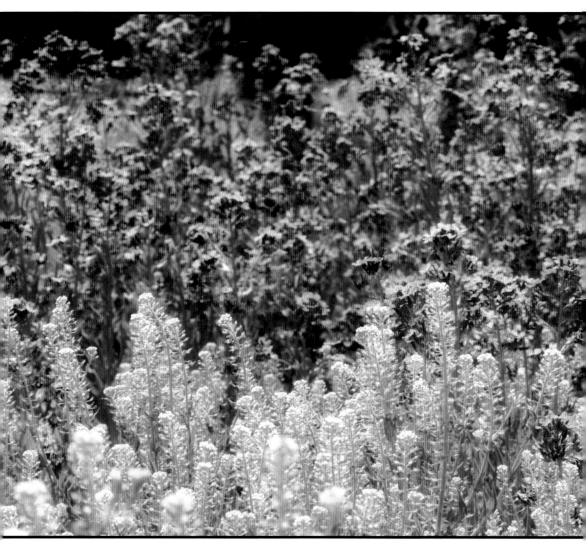

Wildflowers of Glenbrook ~ Eric

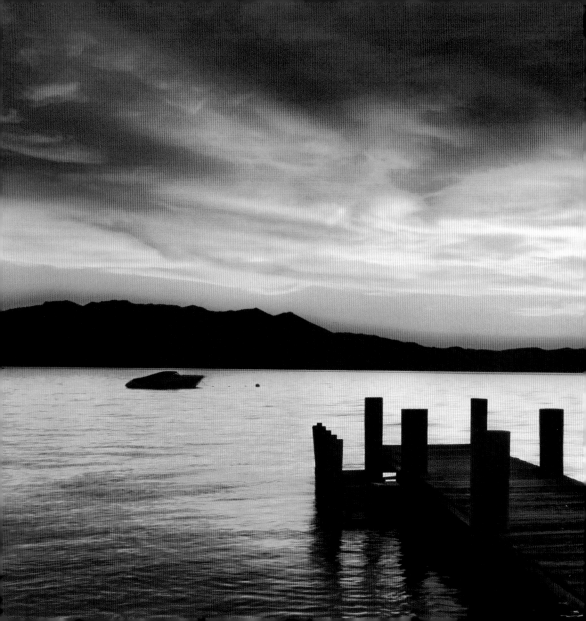

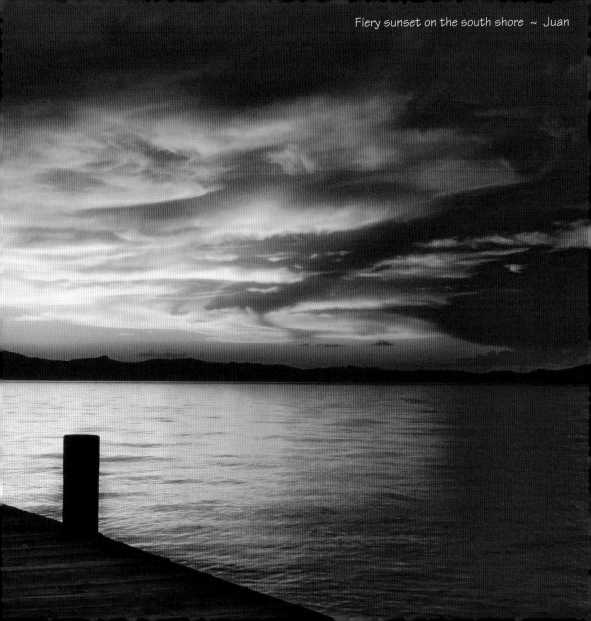

Fiery sunset on the south shore ~ Juan

Juan Acosta

A native of Colombia, South America, Juan moved to the United States with his mother in 1996.

Since 1998 his unique vision and passion for photography have motivated him to explore the medium. He began his career as a portrait and event photographer, operating his own studio in Huntsville, Alabama, where he also worked with his great friend, photographer David Phillips.

In 2003, upon moving to Lake Tahoe, the stunning vistas of the High Sierra inspired his shift into scenic photography. Juan has traveled with Eric throughout the American West documenting its endless beauty.

He currently runs his fine art photography gallery at www.vistapanorama.com.

Eric and Juan working on the next book
~ Photo by self timer

Beata & Eric Jarvis

Beata and Eric Jarvis are professional photographers based in Stateline, Nevada near the shores of beautiful Lake Tahoe.

Their photography pursuits have taken them to many exotic places including Vietnam, Cambodia, Bora Bora, Bulgaria, Croatia, Turkey and Russia.

Of all the remarkable locations that they have been fortunate enough to capture in their images, Lake Tahoe remains the most fascinating.

"Lake Tahoe is, of course, one of nature's great treasures. It is also an amazing resource for the scenic photographer; there is always something new, a different aspect of the lake's beauty to explore. The snow-capped peaks, the play of the water and rocks, the many ways of a Tahoe sunrise... I am thankful to be able to live and work in such a breathtaking place."
- Eric Jarvis

View more of their work at their online gallery at www.jarvisgallery.com.

© 2007 Juan Acosta, Beata & Eric Jarvis

All rights reserved. No portion of this book may be reproduced or utilized in any form, without the prior written permission of the publishers.

Juan Acosta
Vista Panorama
P.O. Box 11696
Zephyr Cove, NV 89448
info@vistapanorama.com
(888) 667-3575

Beata & Eric Jarvis
Jarvis Gallery
P.O. Box 7194
Stateline, NV 89449
images@jarvisgallery.com
(800) 452-7864

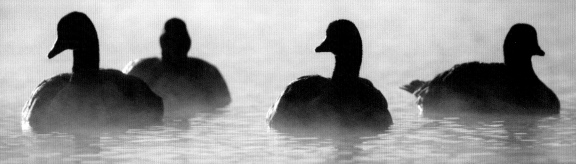

Printed in Colombia by
Panamericana Formas e Impresos S.A.

Print coordination in Colombia by
Pagina Maestra Editores
info@paginamaestra.com

ISBN 978-1-4243-3776-7

Ducks at Kiva Beach ~ Eric